DESIGN & FENG SHUI LOGOS, TRADEMARKS & SIGNBOARDS

DESIGN & FENG SHUI LOGOS, TRADEMARKS & SIGNBOARDS

Evelyn Lip

HEIAN

By Evelyn Lip

Text is in British English

First American Edition 1998
98 99 00 01 02 03 04 05 9 8 7 6 5 4 3 2 1

Heian International Inc.
Publishers
1815 West 205th Street, Suite #301
Torrance, CA 90501
Web site: *www.heian.com*
E-mail address: *heianemail@heian.com*

This edition is for sale in the United States and Canada only, by arrangement with Simon & Schuster (Asia) Pte Ltd

ISBN: 0-89346-864-9

Printed in Singapore

DEDICATED TO

Kenny and Jacqueline
Kai, Seng, Peng, Wan, Kwan and Fatt

CONTENTS

PREFACE

There are very few books on the design and none on the *feng shui* of logos and trademarks. Therefore, it is timely to publish a book on this interesting subject, paying particular attention to its design and feng shui. More companies are being set up and more company executives are becoming design-conscious and very particular about the design of the logos, trademarks and signboards of their companies.

This book is written not just to provide reference materials and ideas for the design of logos, trademarks and placement of signboards but also to make special reference to feng shui and the approach to making an auspicious design. Designers, graphic artists, company executives, students and anyone interested in the field of design and feng shui will find this book useful and interesting.

ACKNOWLEDGEMENTS

My gratitude and special thanks go to the managers and directors of the following corporations who have granted me permission to publish the logos or trademarks of their companies: Westpac Banking Corporation, The Chase Manhattan Bank, N.A., The Nikko Merchant Bank (Singapore) Limited, Bankers Club, Australia and New Zealand Banking Group Limited, Air-India International, Lufthansa, Beth Tikvah Synagogue, Geoff Malone International, Risis Pte Ltd, Aalborg Ciserv (Singapore) Pte Ltd, Decor Arts Gallerie, Arkitek MAA Sdn Bhd, Polychem (M) Sdn Bhd, Wella, Real Estate Developers' Association of Singapore, Singapore National Printers Ltd, DeLima Resort Kuala Muda, Esso, Mok & Associates, Sunrise Sdn Bhd, Ernst & Young, and CYC Shanghai Shirt Co. Pte Ltd.

I wish to acknowledge the suggestion by Mrs Lynne Lee to write a book on logos. She pointed out wisely that this book would be useful to the general public. During the course of writing this book, I had much encouragement from my children, Kenny and Jacqueline, and I appreciate their moral support.

The logos and trademarks designed and proposed by me as well as the reproductions of logos of companies are solely for reference. Further reproduction of these company logos must be done with written permission from the registered companies whilst reproduction of the author-designed logos must be done with written approval from the author.

INTRODUCTION

Since ancient times, Man has used symbols, signs, diagrams and logos in all cultures and civilisations as means of communication and to represent the meaning and nature of their operations. He acknowledged that the inner worth of anything could be displayed by its outward sign and form. So he used symbols to relate to culturally meaningful phenomena in his society and to express his ideology and personal aspirations.

The Egyptians formed endless varieties of symbols with their engraved characters. They used features of the lotus, papyrus, solar disc, vulture, diaper patterns for their ornamentations and they often employed these motifs in their temples and royal tombs.

For example, the lotus and papyrus were logos of "food and mind". In the rock tomb of Ukhhotep I, patterns of overlapping squares, quatrefoils and dots were made as if they were the logos of the tomb. In the tomb of Queen Nefertari at Thebes, numerous images of patterns could be seen and these images could even be inspirational for logo designers.

The Mesopotamians used cuneiforms as symbols. Animals were painted as emblems on shields of warriors by the Egyptians and Romans. Ancient buildings in Rome were finished with mosaic wall panels made of glass tesserae which portray countless attractive symbols.

The Chinese have used symbols and signs since time immemorial. Their logos and trademarks can be based on floral patterns (see drawings on page 11), geometric forms (see drawings on page 25), animals (see drawings on page 46), religious symbols (see Figure 1-5 on page 9) and many other themes. For example, the ancient numerals of the Eight Trigrams, attributed to China's first legendary emperor, *Fuxi* (2852 BC), were a few of the first ancient symbols used by fortune-tellers. These ancient numerical symbols made up the early logos for divination. It was called the *Hetu* and it consisted of dots which were later translated into the Eight Trigrams. *Feng shui* 风水 is the layman's term for *kan yu* 堪舆, the art of design with reference to Chinese culture, thinking, symbolism, earthly environment and cosmological influences. It is important that the design of logos and trademarks refers to the rudiments of feng shui to ensure that its symbolism and graphic presentation are auspicious and they represent the image of the corporation well. It is also the art of placement of buildings and things with reference to the surrounding natural and man-made environment. Therefore, the placement of signboards should be well placed in an auspicious position with reference to the surrounding environment.

Today, the commercial sector is affluent and conscious of corporate image and prestige. Most business houses require signboards and trademarks for the advertisement of their goods and services. It is important that these business houses employ qualified designers to create their logos and make their signboards. Executives of these business houses too, as far as possible, should understand the meaning and process of design in order to judge and choose the right design. Designers, on the other hand, must have the specific skills and techniques to present and sell creations that will suit their clients.

Having knowledge of design on logotypes, logograms, sign-boards and trademarks alone is not sufficient for designers and managers of business corporations. If the design is an inauspicious symbol, it may affect the morale of the company staff. Therefore, it is of great importance that the design of logos, trademarks and signboards reflects the image and function of the corporation it represents and is auspicious in meaning. Hopefully, this book, possibly the very first covering the design and auspiciousness of logos and signboards of companies that are long established as well as those that arc to be formed in the near future, will prove most useful to all who are concerned and interested in the subject.

CHAPTER ONE

LOGOTYPES, TRADEMARKS AND SIGNBOARDS

The logo of a company or organisation is a special design either in a symbolic and graphic pattern or written character which represents the corporate image of the company. A logotype is a single type of diagram consisting of one, two or three letters that represent a business house, corporation or private organisation. A logogram is a symbol or character that is used to designate a word that portrays the dealings of a business house, corporation or private organisation. In this book, the word logo is used to represent either a logo, a logotype or a logogram which is used to promote the products or services of a company. A trademark is like a logo and may be a character or a symbol but it is used to indicate the connection between goods bearing the character or symbol and the owner of the mark during the course of trading the goods.

When a business corporation wishes to protect the copyright of the logo or trademark, it registers it by making an application to the Patent Office or to the appropriate government office. The copyright, once given, is for an unlimited period.

Logos and trademarks must be visually interesting and legible as well as informative. They should look distinctive and reveal the nature of the company or product. They must be original to be patentable. If a trademark resembles or appears exactly like another design, it will cause confusion to the purchasers of the products. Therefore, a trademark should be carefully designed, making reference to trademarks that have been used before and making sure it represents the products. For example, if the trademark is for a bottle of ink made by a family organisation and the surname of the family is *Sun* 孙 then the trademark may bear the Chinese character of *Sun* but the designer must make sure that the way *Sun* is written is different from other trademarks that also carry the character *Sun* (see Figure 1-1 for three possible ways of writing the word *Sun*).

| Modern | Zhou dynasty | Han dynasty |

Figure 1-1

Signboards are important elements for business houses because they advertise the nature of the business and the activities of the company. Attractive and well-placed signboards enhance the image and the feng shui of the company.

MEANING AND DESIGN OF A LOGO AND A TRADEMARK

A logo is a symbol used to convey the significance of the private, public or corporate image of a company. It may reveal the activities and functions of the company it represents. Therefore, it should be uniquely designed to present clarity, balance, appropriateness, attractiveness and simplicity. Clarity and simplicity are important because those who read it must not be confused by its design. Balance is essential because only well-proportioned and balanced graphic forms are visually pleasing to the eye since perception is a complex interactive process which involves judgment.

Appropriateness is of great importance because it is supposed to reveal the company's dealings and functions.

Similarly, a trademark should be designed with all the qualities mentioned above for a logo because it represents the goods of a trading company. It is important, therefore, that the design of a logo or a trademark fulfil the following conditions:

1. It should be culturally appropriate.

2. A logo should bear an intended image and reveal the nature or activities of the company and to reflect the commercial goals of the organisation it represents, whereas a trademark should be designed to represent the goods of a trading company.

3. It should be a means of visual communication.

4. It should be balanced and, therefore, be either black and white or balanced in colour.

5. A logo should demonstrate a sense of rhythm and proportion.

6. It should be artistic, elegant, simple and yet have an emphasis or focal point.

7. It should be harmonious in design.

8. It should incorporate appropriate lettering that helps to put the intended message across logically and unambiguously.

9. It should be auspicious in terms of feng shui, and balanced in *yin* and *yang* elements.

CULTURAL INFLUENCE

Culture reflects the accumulated behaviours of a people and society. The visibility of a specific logo or signboard is determined by the choice of legends used and the communicative qualities depend on the understanding of the symbols used (see how elaborate the signboard structure, *pailou* 牌楼, in Figure 1-2 is).

Symbols adopted in the logo or signboard should be relevant to the cultural and historical background of the company. For example, if the logo of a particular company reflects a Chinese symbol, it may be assumed that the company deals with goods

Figure 1-2
Pailou 牌楼 bearing signboards

or offers services associated with the Chinese or Orientals. Figure 1-3 shows the logo of a Chinese company that builds factories.

Figure 1-3

Another example of a logo that reflects the dealings of a Chinese company which sells traditional Chinese cultural items has a pagoda as a symbol (Figure 1-4).

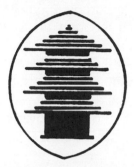

Figure 1-4

Sometimes words in languages other than English are used. An example of using Hebrew in the logo of the Beth Tikvah Synagogue is shown in Figure 1-5.

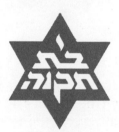

Figure 1-5

A company that makes Dutch shoes and sandals has a logo as shown below (see Figure 1-6).

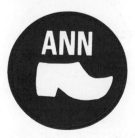

Figure 1-6

IMAGE

The logo of a company should represent the image and commercial goals of the company and reflect its activities and functions. It should give a positive corporate image through maximising favourable messages in the form of signage and graphics.

In portraying the company's activities and standards of management, it subtly "sells" the company to its selected audience. For example, a company that has long been established as a reliable firm of managers associated with a noble family would use the symbol of a coat of arms over which the name of the company is imprinted (see Figure 1-7).

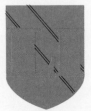

Figure 1-7

Another example (see Figure 1-8) shows the logo of an electronics company with the sign of a lightning bolt at the centre of two circles. This logo reflects the image of the company as being decisive, efficient and professional. The lightning bolt suggests electronic and other electrical goods being sold by the company.

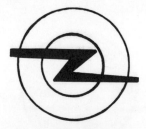

Figure 1-8

This logo combines two circles with an intuitive sign (zigzag) combining the Gold and Water Elements.

A trademark may not necessarily reflect a company's corporate image but it is an emblem of the goods it represents. It should be a symbol easily recognisable as being associated with the products or goods sold. The following sketches show some artistic trademarks for floral products and florist-oriented businesses (see Figure 1-9).

Figure 1-9

Some companies use well-known symbols such as horoscopic symbols for their logos as shown in Figure 1-10.

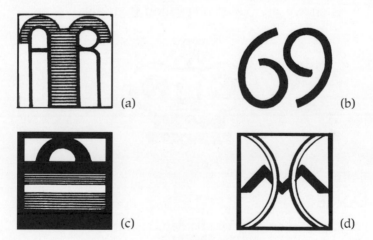

Figure 1-10

(a) Aries Records' logo: The symbol of Aries is combined with the letters AR.
(b) Cancer Coffee House: This logo is derived from the sign of Cancer, expressing a sense of movement and contrast.
(c) Libra Locksmith: The symbol of a lock is combined with the symbol of Libra.
(d) Pisces Fishing: Derived from the sign of Pisces, this logo has a sense of balance.

VISUAL COMMUNICATION

In many ways, a logo or a trademark is a graphic pattern, so the approach to its design is similar to that of the graphic design of signage and other communicative elements. Shapes, lines and spaces are introduced in such graphic designs. These elements may make or break a good design pattern.

Logical creative symbols that can be easily read make good logos because they relay the appropriate messages across as directly and as aesthetically pleasant as possible. According to psychologists who have studied the creative process of visual communication, the human eye has the ability to absorb only a limited number of unrelated elements. If it is confronted with too many elements, it may not understand and may reject the imagery. Therefore, an over-complicated logo pattern cannot be understood and so it defeats the purpose for which it is intended. For example, the logo for a company selling gems, Man Jewels, is shown below (Figure 1-11). The design has too many elements and the diamonds or jewels shown are out of proportion (too large).

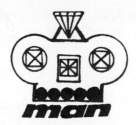

Figure 1-11

BALANCE

The equation of balance can be demonstrated by Figure 1-12(a) in which two identical balls are placed on opposite sides and are in perfect equilibrium. They assume a central axial fulcrum with equal weight and depict symmetry. However, when the balls vary in size, they have to be placed at different positions in order to achieve balance (see Figure 1-12(b)). Asymmetry creates tension but by locating the balls at different positions, balance can still be achieved.

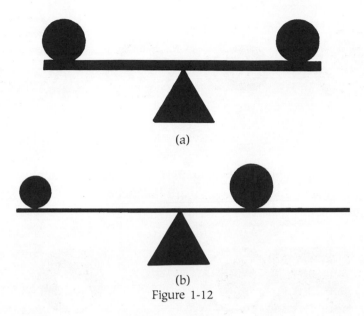

(a)

(b)
Figure 1-12

Balance in a logo design is achieved when each part of the design seems to need the other to be in a state of equilibrium and unity as demonstrated in the next few diagrams. As we have seen, the elements in a design may be moved from one side to another to achieve a balanced composition. It is easy to achieve a balanced composition through symmetrical layout as shown in Figures 1-12(a) and 1-13.

Figure 1-13

Balance can be achieved in two ways. Firstly, the graphics must be balanced in design by ensuring that the shapes, lines and spaces employed are sensitively incorporated so that either symmetrical or asymmetrical balance is achieved (see Figure 1-14).

Figure 1-14

Secondly, balance in feng shui terms must be achieved so that the yin and yang elements are balanced as demonstrated in Figure 1-15.

Figure 1-15

Figures 1-16(a) and (b) show the initials of two companies, ob and SL. The company with the initials DD is simply super-imposed on a black circular disc for boldness and simplicity in design (see Figure 1-16(c)). The letterings are carefully chosen for the display of strength and simplicity and they are composed in yin and yang fashion.

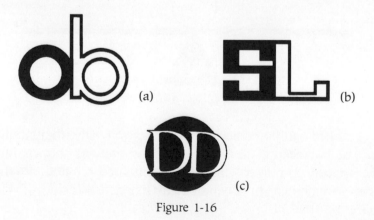

Figure 1-16

PROPORTION IN DESIGN

Architects, interior decorators and graphic designers are fully aware of the aesthetics of proportions such as those devised for centuries based on the Golden Means and other theories on proportions. Ancient designers in Egypt, Rome, China and many other parts of the world had used certain canons of proportion to achieve the intended aesthetics. Modern designers know that exciting and well-proportioned designs can be achieved through the proper use of shapes and forms that relate to each other.

It is important to experiment and study proportions during the course of designing a logo or signboard. For example, a square can be subdivided in many ways as demonstrated in Figure 1-17.

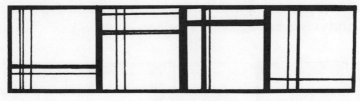

Figure 1-17

Given a certain size or area to work with, the area can be divided into various proportions capable of presenting different interests and challenges to the eye. Lines, shades, shapes, textures and colours make emphasis or focal point, and the eye responds to them differently depending on where they are located in the design.

A noted artist, Piet Mondrian, was famous for his pictures which demonstrate interesting proportions in abstract art. Inspired by him, an example is created in Figure 1-18. It consists of interlocking rectangular strips with vivid primary colours. The horizontal and vertical lines are intended to convey the impression that art has to attain an exact equilibrium through the creation of pure plastic forms created as abstract and contrasting patterns. The two contrasting patterns are to be in equivalence. By means of abstraction and opposition, unity is achieved.

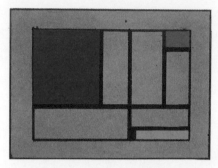

Figure 1-18
Painting using proportion and colour
scheme to give balance

The sketches in Figure 1-19 show (a) an imbalanced composition showing the focal point as a thick black line on the left; (b) a balanced composition with a thick line and a black circle; (c) and (d) variations of balanced compositions.

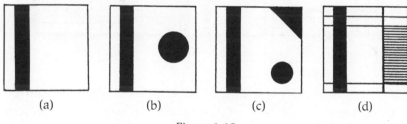

(a) (b) (c) (d)

Figure 1-19

ARTISTIC ELEGANCE

Art has been well integrated into the culture of societies and value systems have been formed since time immemorial. The design of logos and trademarks requires the designer to take into account artistic values. Thus, a designer puts in tremendous effort to give full expression to the design in order to produce an effective and visually pleasing logo. The size, shape, colour and legibility of the logo have to be carefully considered for elegance and beauty. Some interesting design motifs using lines to express rhythm and elegance are shown in Figure 1-20.

<center>(a) (b)</center>

<center>Figure 1-20</center>

Several examples on proportions are given below to illustrate the initial steps in studying this aspect of design (see Figures 1-21 and 1-22).

A rectangle may be subdivided into squares and each square may be textured to give a variety of light and shade to the overall design.

<center>(a) (b)</center>

<center>Figure 1-21</center>

Proportion and subdivision of a square may be studied by trial and error, and by subdividing the square in various ways and examining the spatial quality and rhythm created as shown.

<center>(a) (b) (c) (d)</center>

<center>Figure 1-22</center>

HARMONY

Harmony should be achieved in a logo design in two ways. Firstly, the design should demonstrate unity in the motifs and design elements, and secondly, in feng shui terms, the design elements should have harmony in form and colour. When colours are used, yin (cool) and yang (warm) colours must be employed harmoniously. It is possible to use contrasting colours and even very strong colours to give a vibrant and harmonious colour scheme to the logos as demonstrated in Figure 1-23.

Figure 1-23

It is important to achieve "unity in variety" – variety in the interchangeability of patterns, lines and masses. Unity created by rhythms of the design should be vibrant and alive. The forms or proportions created should be evolved naturally to suit the purpose of the logo or signboard.

The *taiji* diagram (Figure 1-24) is a unique example of a perfectly balanced and harmonious design.

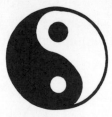

Figure 1-24

In Figure 1-25, the initials of a company, CD, is composed in a simple and powerful logo that demonstrates the harmonious balance of yin and yang qualities.

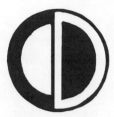

Figure 1-25

COLOURS

Colours in a logo are very important elements and they are incorporated in the design to enhance the sense of balance. Yin and yang colours are used to illustrate contrast and harmony as demonstrated in Figure 1-26.

Figure 1-26
Complementary colours, yellow (yang)
and purple (yin)

LETTERING

Lettering may be derived from the Roman, San Serif or Script typefaces and it may be transformed into abstract forms to give an effective presentation (see Figure 1-27).

Most logo and signboard designers know the various topography of lettering and explore the various styles of typefaces before making a final decision. Important considerations for the right choice of lettering are legibility, spacing, appropriateness and significance. In the selection of the type and style of lettering,

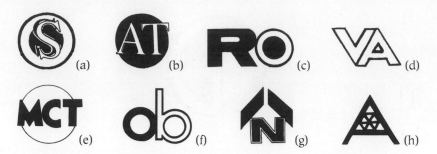

Figure 1-27

Logos for (a) a company selling plates and kitchen wares, (b) a company with initials AT, (c) a company with initials RO, (d) a company with initials VA, (e) a company with initials MCT, (f) a company with initials ob, (g) a builder named Nat, (h) a company selling diamonds.

it is also important to ensure that the size and weight of the letters are not overbearing or too insignificant so as to upset the entire composition. Lettering used must be legible, uncluttered and clear.

Besides the usual letter types, calligraphy, cursive and free hand lettering may be used. These may be abstract and may be incorporated into a graphic image to form an abstract and attractive logo or symbol as in Figure 1-28.

(a) (b)

Figure 1-28

CHAPTER TWO

THE MEANING OF FENG SHUI

Feng shui is the skill and art of design and placement with reference to nature and the cosmos. It was practised by the Chinese for thousands of years to achieve balance and harmony in their cities, homes, palaces, public buildings, private places of work, landscaped gardens and temples.

A good life is supposed to be achieved through balance and harmony, and a good design is accomplished through the balanced application of yin and yang elements in the design. All things, shapes and colours can be classified under yin or yang, and their Elements and nature of yin and yang relate either harmoniously or disharmoniously to people depending on the nature and Elements of the people. A chart that reveals the element of people depending on their time of birth is shown in Table 2-1.

The nature of shapes and colours will be discussed later but it is important to know that the elements of birth are closely associated with directions (for the hanging of signboards and placement of logos) and so when signboards of companies are hung, reference may be made to Table 2-2.

Five Elements	Time of Birth
Wood	11 pm to 3 am
Fire	3 am to 7 am
Earth	7 am to 11 am
Gold	11 am to 3 pm
Water	3 pm to 11 pm

Table 2-1

Elements	Directions
Wood	North
Fire	East
Earth	South-east
Gold	South
Water	West

Table 2-2

FENG SHUI OF LOGOS

Feng shui was first practised in China thousands of years ago. Since then, it has been incorporated into the art of siting Chinese buildings and has become a part of the Chinese culture. It is based on the theory of the balance of yin and yang and the balance of the Five Elements (Gold, Wood, Water, Fire and Earth).

It is believed that all things, natural and man-made, must be in balance and harmony in order to benefit from the workings of nature. It is a good practice to use appropriate symbols and decorations not just for the interiors of buildings but also in all practices and dealings that concern the well-being of Man. The concept that Man benefits from the balance and harmony of yin and yang in all things is based not just on theories of the yin/yang school but is also deeply rooted in the Chinese culture.

THE FIVE ELEMENTS

The concept of the workings of the Five Elements is seen in the physical world and also in nature. According to Chinese beliefs,

all things in the physical world are classified under the Five Elements of Gold, Wood, Water, Fire and Earth which are closely associated with nature.

AUSPICIOUS COMBINATIONS OF ELEMENTS

The Five Elements are associated with shapes, so the use of shapes in a logo should be made with reference to the compatibility of the elements. The Gold Element is associated with round and oblong shapes, the Wood with tall, thin and I-shapes, the Water with zigzag and shapes that suggest flow and movement, the Fire with conical and pyramidal shapes, and the Earth with square shapes.

The following list shows favourable combinations of elements and numbers:

❊ Gold (round, white) and number 9 with Water (zigzag, black) and number 6

❊ Wood (rectangle, green) and number 8 with Fire (triangle, red) and number 7

❊ Water (zigzag, black) and number 6 with Wood (rectangle, green) and number 8

❊ Fire (triangle, red) and number 7 with Earth (square, yellow) and number 5

❊ Earth (square, yellow) and number 5 with Gold (round, white) and number 9

Any one of the Five Elements is associated with other Elements in either a productive, positive and compatible manner or in an unproductive, negative and incompatible manner. Pairing of the Elements and shapes must be done with care to produce the best results.

Elements that are compatible and can be paired are:

❊ Water with Wood

❊ Wood with Fire

❊ Fire with Earth

❊ Earth with Gold

❊ Gold with Water

Elements that are incompatible and should not be paired are:

❊ Earth with Water

❊ Water with Fire

❊ Fire with Gold

❊ Gold with Wood

❊ Wood with Earth

When three Elements are used, the compatible combinations are:

❊ Gold, Water, Wood

❊ Gold, Earth, Fire

❊ Gold, Water, Water

❊ Gold, Gold, Water

❊ Wood, Wood, Fire

❊ Wood, Fire, Earth

❊ Wood, Water, Gold

❊ Wood, Fire, Fire

❊ Water, Water, Wood

❊ Water, Wood, Wood

❊ Water, Wood, Fire

❊ Water, Gold, Earth

❊ Fire, Wood, Water

❊ Fire, Earth, Gold

❊ Fire, Earth, Earth

✤ Fire, Fire, Earth

✤ Earth, Gold, Water

✤ Earth, Fire, Wood

✤ Earth, Gold, Gold

✤ Earth, Earth, Gold

The following drawings in Figure 2-1 show the shapes of the various Elements and their combinations as well as the auspicious and inauspicious combinations.

 1. Earth — This square represents the Earth Element.

 2. Gold — This circle represents the Gold Element.

 3. Fire — This triangle represents the Fire Element.

 4. Wood — This elongated shape and other rectangular shapes represent the Wood Element.

 5. Water — This wave-like intuitive shape represents the Water Element.

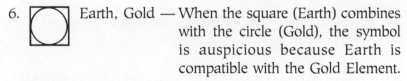 6. Earth, Gold — When the square (Earth) combines with the circle (Gold), the symbol is auspicious because Earth is compatible with the Gold Element.

 7. Gold, Gold — This is an average sign in feng shui terms because it is made up of only one Element.

 8. Fire, Gold — This is not an auspicious sign because the Elements clash.

Figure 2-1

9. Gold, Wood — This is not an auspicious sign because the Elements clash.

10. Gold, Water — This is an auspicious sign because the Elements are compatible.

11. Fire, Earth — It is an auspicious symbol because Fire and Earth are compatible.

12. Gold, Fire — An inauspicious symbol because the Elements clash.

13. Fire, Fire — An average sign because it is made up of only one Element.

14. Fire, Wood — Fire and Wood are neutral Elements.

15. Water, Fire — An inauspicious symbol because the Elements clash.

16. Wood, Earth — An inauspicious sign because the Elements clash.

17. Wood, Gold — An average sign in feng shui terms.

18. Wood, Fire — An auspicious and harmonious sign.

19. Wood, Wood — An average sign because it is made up of only one element.

20. Wood, Water — An auspicious symbol because the Elements are in harmony.

Figure 2-1 (contd)

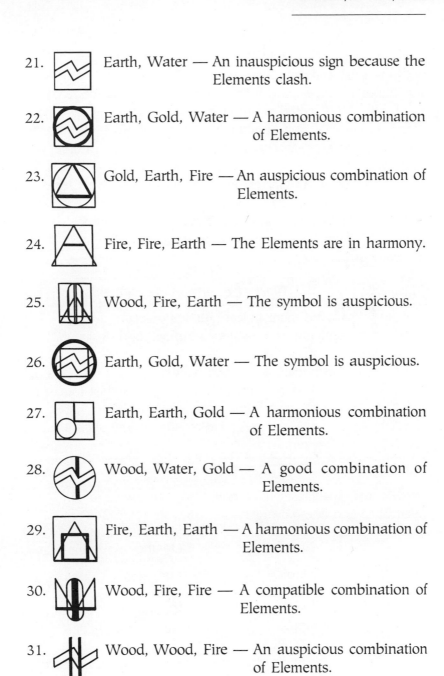

21. Earth, Water — An inauspicious sign because the Elements clash.

22. Earth, Gold, Water — A harmonious combination of Elements.

23. Gold, Earth, Fire — An auspicious combination of Elements.

24. Fire, Fire, Earth — The Elements are in harmony.

25. Wood, Fire, Earth — The symbol is auspicious.

26. Earth, Gold, Water — The symbol is auspicious.

27. Earth, Earth, Gold — A harmonious combination of Elements.

28. Wood, Water, Gold — A good combination of Elements.

29. Fire, Earth, Earth — A harmonious combination of Elements.

30. Wood, Fire, Fire — A compatible combination of Elements.

31. Wood, Wood, Fire — An auspicious combination of Elements.

Figure 2-1 (contd)

Gold is associated with the West and the colour white; Wood with the East and the colour green; Water with the North and the colour black; Fire with the South and the colour red; and Earth with the Central position and the colour yellow. These elements succeed one another in a cycle of either production (compatibility) or destruction (incompatibility) interaction. Therefore, the colours and graphic forms adopted in a logo should follow the theory of the working of the Five Elements as demonstrated on pages 25–27.

The Five Elements should be used with reference to the types of business and organisation that are associated with them as listed in Table 2-3:

Elements	Types of Business/Organisation
Gold	Government offices, Justice offices
Wood	Agricultural businesses, artists' and designers' studios
Water	Businesses dealing with labour, maid agencies
Fire	Businesses dealing with manpower, fast food outlets
Earth	Financial centres, banks, shares and securities brokers

Table 2-3

Medical specialists may note that the Five Elements are referred to five internal organs as listed in Table 2-4:

Elements	Organs
Gold	Lungs
Wood	Liver
Water	Kidney
Fire	Heart
Earth	Spleen

Table 2-4

The Five Elements are compatible with certain numbers as follows: Gold with 9, Wood with 8, Water with 6, Fire with 7 and

Earth with 5. Table 2-5 sums up the above theory on the compatibility of the Five Elements and their corresponding numbers.

Compatible Elements	Numbers
Water and Wood	6 and 8
Wood and Fire	8 and 7
Fire and Earth	7 and 5
Earth and Gold	5 and 9
Gold and Water	9 and 6

Table 2-5

THE YIN AND YANG OF LOGO DESIGN

Yin represents the feminine qualities while yang denotes the masculine qualities. Thus all things, both natural or man-made, can be classified as yin or yang. It is believed that desirable results are obtained when there is a perfect balance of the yin and yang qualities in things.

The belief in the balance of yin and yang in nature was reinforced during the Zhou dynasty. It was believed that the union of the yin and yang elements in nature and in man-made things produced harmony and beauty. Several examples shown in Figure 2-2 demonstrate the logos with yin and yang elements.

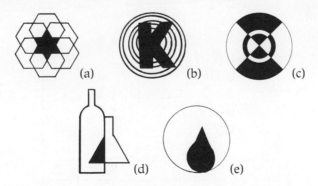

Figure 2-2

Logos for (a) a company dealing with mild steel grilles and shutters, (b) a company named Ken dealing with records, (c) a company selling dartboards, (d) a chemical company, (e) a water purification plant.

THE YIN AND YANG OF THE ALPHABET

Letters in the alphabet written with an even number of strokes are yin while letters written with an odd number of strokes are yang. Generally, the letters can be classified as yin or yang as shown in Table 2-6.

Yin	Yang
a A	c C
b B	
d D	
E	e
f	F
g	G
h	H
i	I
j J	
	k K
	l L
	mM
n	N
	o O
p P	
q Q	
r	R
	s S
t T	
u U	
	v V
w W	
x X	
y Y	
	z Z

Table 2-6

The table acts only as a rough guide because the yin and yang of a letter depends on how it is actually written. For example,

if the O is written as a broken circle () for graphic effect, it then becomes yin instead of yang (see Figure 2-3). Another example, using the letter R, shows that R can be yin if it is written as r or yang if it is written as R.

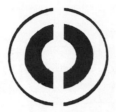

Figure 2-3

One should try to balance the yin and yang in the letters used in logos and trademarks. Care has to be taken to place letters that are the initials of a corporation in balance. Several examples (PH, DY, COD, EL) of balanced lettering in terms of yin and yang are shown in Figure 2-4. However, it is also important to check the Elements of the letters for the balance of the Elements.

The alphabet can also be classified under the Five Elements as shown in Table 2-7.

Gold	Wood	Water	Fire	Earth
c	g	b	d	a
q	k	f	j	w
r		h	l	y
s		m	n	e
x		p	t	o
z			z	i
				u
				v

Table 2-7

The classification implies that compatible letters are those under Water and Wood, Wood and Fire, Fire and Earth, Earth and Gold, and Gold and Water. For example, it is auspicious to combine the letters b and g, k and d, j and a, w and q, and r

31

and m. It is less auspicious to combine those under Earth and Water, Water and Fire, Fire and Gold, Gold and Wood, and Wood and Earth. For example, the letters b, f, h, m or p should not be combined with d, j, l, n, t or z (see Figure 2-4 for examples).

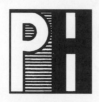

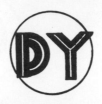

<div style="display:flex;">

(a)
P and H are both of Water Element.

(b)
D is of Fire Element and it is compatible with Y (Earth).

</div>

(c)
C is Gold, D is Fire and O is Earth. The combination of Gold, Earth, Fire is auspicious.

(d)
E is Earth and L is Fire. Fire and Earth are compatible.

Figure 2-4

FENG SHUI OF MEASUREMENTS FOR LOGOS AND SIGNBOARDS

According to the practice of feng shui, there are auspicious and inauspicious measurements for logos and signboards. Even units of measurements are yin while uneven units are yang.

Some auspicious units of measurements are shown in Table 2-8 in centimetres.

Yin	Yang
2	3
16	17
18	19
20	21
22	23
38	39
40	41
42	47
48	61
62	67
86	69
88	81
100	89
108	125
128	145
146	147

Table 2-8

CHAPTER THREE

THE DESIGN OF SIGNBOARDS

Signboards in a shopping complex fulfil certain functions such as giving information, directions and providing instructions during an emergency. They should therefore be designed to give clear messages. Signboards of shops should give an appropriate image of the shop so that the commercial activities and goods being sold there are clear to the shoppers. Signage on the shop front and entrance is very important and should be attractive and inviting because public awareness of the shop certainly brings in more business.

Signboards should be designed with reference to the principles of design for logos mentioned earlier because its feng shui, graphic and visual qualities are achieved in similar approaches. Signboards should be pleasing to the eye and create human awareness of the environment. It should complement the overall atmosphere of a place and highlight the landscape and ambience of an area. Balanced in the Five Elements, yin/yang, dimension, measurement, shape, colour and the overall design, it should be made with reference to the surrounding environment. It should be securely fixed to the supporting structure.

There are various types of signboards. Signboards in the parks and recreation areas are for conveying information, showing maps, giving instructions on prohibited activities, location of offices and public facilities. Street signs give instructions on speed limits, directions, pedestrian crossings, etc. Signboards in zoos give the location of the animals and birds, directions and location of the various facilities. In university campuses and schools, signboards give the location of the various faculties and classrooms, parking areas, canteens and the administration office. Signboards in railway stations give the location of public facilities, ticket and locker areas. Signboards in airports are of great importance because the communication within the airports must be efficient. The signs indicating the departure and arrival halls, the lounges, the amenities and airline counters must be clear and prominent. In shopping complexes, signboards are so important that it may make or break their commercial viability. Attractive and good feng shui signs bring in customers. Signboards in hotels must give clear directions to lifts, entrances and exits, public facilities, restaurants and rooms.

There are many suitable materials for making signboards. The most common ones are hardwood, granite, tiles, marble, stone, terrazzo, mosaic, ceramics, plastic, stainless steel, aluminium, cast iron, glass, optical fibre, copper, and concrete. Sometimes a few types of materials are combined to make an interesting signboard. For example, stainless steel letters may be mounted on a granite panel, steel plates with enamel silk screen finish may be mounted on an aluminium framework and cast iron pipes may support a copper plate that bears the sign.

It is important to ensure that the colour scheme of a signboard is auspicious in feng shui terms. Harmonious colour schemes for signboards are white, red and green; white, green and yellow; white, red and purple; white, green and red; red, yellow and purple; and yellow, white and red.

FENG SHUI OF SIGNBOARDS

A signboard is not just a device for giving directions and

information. It is often the most important element that represents the name and image of a company. The Chinese regard it as the "face" (the reputation) of the company. In the olden days, a Chinese businessman would guarantee his customers good service or good quality products by saying, "If my products are substandard, I grant you permission to pull down my signboard". Therefore, a signboard should be located in the *qi* 气 area (area with energy of the Earth in feng shui terms) of a room. The following diagrams in Figure 3-1 show the qi locations with reference to the orientation of a place.

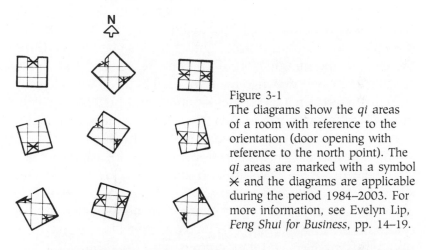

Figure 3-1

The diagrams show the *qi* areas of a room with reference to the orientation (door opening with reference to the north point). The *qi* areas are marked with a symbol ✕ and the diagrams are applicable during the period 1984–2003. For more information, see Evelyn Lip, *Feng Shui for Business*, pp. 14–19.

Qi may be balanced (*sheng qi* 生气) or imbalanced (*si qi* 死气). Good or balanced qi areas are indicated in Figure 3-1. Poor or imbalanced qi areas are areas where there is too vibrant qi. For example, the end of a long corridor may have too vibrant qi. Areas where ventilation is poor have *si qi* 死气 and they too are to be avoided. Therefore, where signboards are hung, there should be *sheng qi* rather than *si qi*.

Good feng shui is obtained by doing the right thing at the right time and at the right place. Thus, it is important to choose an auspicious time to install the signboard especially when it bears the company's name.

The shape and colour of signboards should be in harmony with the Element of the head of the organisation. It is important

to check the materials used, the shape employed and the colour scheme of the sign against the Elements of the business.

LIGHTING AND COLOUR OF SIGNBOARDS

Light enables us to perceive the contrast of shades and forms. Colours and forms owe their appearance to light falling on them. Without light no colour or form can be seen. The function of light on colours is partly to control the brightness of surfaces, the level and distribution of reflected light.

Lighting and colour coding are important devices in the design of signboards. Their appropriate usage is essential. For example, too intense or bright lighting causes glare which hurts the eye. By the introduction of appropriate lighting and colour scheme, the eye is drawn to the signboard in a comfortable way. Visual comfort depends on the distribution of brightness. Maximum visual comfort is obtained when the general surroundings of the signboard are not below one-tenth of the brightness of the signage because the glare results from excessive light and contrast.

There are three ways to introduce an appropriate colour stimulus on a signboard, namely: (1) using an appropriate hue as the dominant colour and contrasting it with two other tints of colour on the opposite side of the colour wheel (see Figure 3-2); (2) contrasting light and dark colours; and (3) contrasting pure with clouded colours.

Figure 3-2
Colour wheel

PLACEMENT OF SIGNBOARDS

Good signage is an integral part of building design and, therefore, should be carefully considered right at the start of the building design. Signboards should be placed after the feng shui of the entire site and building has been assessed. For general reference, a chart may be drawn as a rough guide (see Table 3-1).

Favourable Position	*Colour Scheme of Signboard*
South-east / North-west	White, red and green
South	White, green and yellow
South-east / South	White, red and purple
South-east / North	White, green and red
South / North-west	Red, yellow and purple
South-west / West	Yellow, white and red

Table 3-1

The location of signage of a tall building may be right at the top of the building as shown in Figure 3-3. At a high level, the signage has to be substantially large in scale and brightly lit to be legible from afar. To be visible to people at street level, the signage of a building has to be at a level easily seen and read.

Figure 3-3

39

Sometimes canopies and hoods are cantilevered above the entrances of buildings and they carry signage to attract the attention of passers-by. Sometimes the signage may be placed vertically on a vertical building feature as in Figure 3-4.

Figure 3-4

For low-rise commercial buildings, signboards are hung on the walls or placed across the front of the buildings. All kinds of shapes and forms of signboards have been used. It is important to make reference to the list of acceptable feng shui shapes and elements discussed in an earlier chapter. For example, if round signage is used, ensure that it is combined with a square or a flowing line as shown in Figure 3-5.

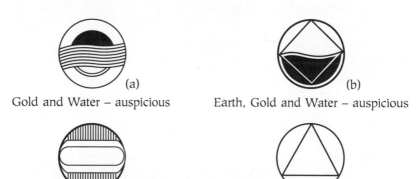

(a)
Gold and Water – auspicious

(b)
Earth, Gold and Water – auspicious

(c)
Gold and Wood – inauspicious

(d)
Fire and Gold – inauspicious

Figure 3-5

CHAPTER FOUR

THE SYMBOLS AND GRAPHICS OF LOGOS, TRADEMARKS AND SIGNBOARDS

A logo or trademark design is two-dimensional, yet dynamic planes seen as being tilted or rotated away from the picture plane can create a three-dimensional effect. Visual linkages of design elements and three-dimensional compositions make dynamic imagery and symbols of communication which are most important especially when the design is for a commercial corporation. The colour scheme and the signage reflects the prestige and image of the company. The first impression created by the logo forms a lasting image of the company it represents.

The design of logos is not limited to the linework and shape of the design elements but also the spatial quality within the logo. The quality of the space is important as it affects the entire design. An expert logo designer should also be a sensitive graphic designer because he deals with space, forms and lines. His sensitivity and awareness of forms, shapes and colours help him in solving a design problem. In his design, he should try to be fully conscious of what he sees from all possible angles within the confines of the logo design. He has to detect with a keen sense of observation,

the defects and other considerations which affect the overall design. The combination of forms, lines and space, colour scheme, pattern and texture do affect the logo in many ways.

Consciously controlled attention and awareness of the placements of the elements of design help to realise the potential in achieving a harmonious logo. In order to achieve the concept of a good design, the designer must understand the principles of unity, balance, yin and yang rhythms, complementary colour scheme and compatible usage of shapes.

Careful and correct use of geometric shapes such as the square, circle and triangle must be grasped to give appropriate significance to the space within a logo. Several examples of logos based on the diagrams of a globe portray the worldwide connections the companies have established. The initials of the companies are simply superimposed on the diagram of the globe (see Figure 4-1).

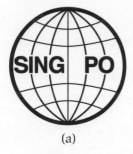 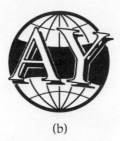 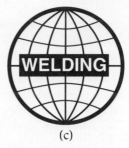

(a) (b) (c)

Figure 4-1

Wholesome and balanced spaces are acceptable. Shapes that are irregular, imbalanced, awkward or bear an unfortunate significance are poor symbols. This is so because Man, who sees the design, is a sensitive being who reacts consciously and subconsciously. As he observes the composition of the spatial concept, the proportion and scale of the logo, he notices the significance of colours and textures, auspicious as well as inauspicious shapes. Besides shapes, symbols and spatial elements, the designer also employs abstract expressions which are visual inventions for the formation of images.

Signboards are made and seen in three dimensions. Graphics and colour scheme on signs are just as important as trademarks and logos. The texture of the materials used for signboards can make a remarkable difference to the graphic finish of the sign.

CHINESE AND ORIENTAL SYMBOLS

Chinese and Orientals have used symbols to represent their desire and wishes since time immemorial. To them, colours and shapes are not used just for their qualities in terms of colour scheme and graphic beauty but mainly for their significance in symbolism. Oriental symbols can be divided into four categories for logos, namely, animal, plant, natural phenomenon and geometry. Trademarks employing these categories are shown in Figure 4-2.

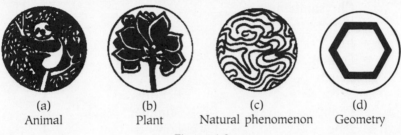

| (a) | (b) | (c) | (d) |
| Animal | Plant | Natural phenomenon | Geometry |

Figure 4-2

The lists of symbols relevant to the design of logos and trademarks, complete with their significance in symbolism are shown below:

Symbols (Animal)	Significance
Bat	Prosperity
Bear	Strength / yang quality
Crane	Longevity
Deer	Wealth
Dragon	Power
Eagle	Strength
Elephant	Strength / wisdom
Fish	Success

Table 4-1

Symbols (Animal)	Significance
Fox	Cunning
Lion	Strength
Phoenix	Yin power
Pig	Wealth
Rooster	Reliability
Snake	Cunning
Tiger	Courage
Tortoise	Longevity
Unicorn	Wisdom

Table 4-1 (contd)

Symbols (Plant)	Significance
Bamboo	Longevity
Chrysanthemum	Autumn
Cypress	Longevity
Iris	Spring
Loquat	Luck
Peach	Longevity
Peacock	Beauty
Peony	Summer
Pine	Longevity
Plum	Endurance

Table 4-2

Symbols (Natural Phenomenon)	Significance
Cloud	Spiritual quality / heavenly blessing
Lightning	Striking / swiftness
Rain	Union (yin and yang)
Rising sun	Confidence
Setting sun	Downward trend
Sun	Spring / beginning
Water ripples	Wealth
Wind	Movement

Table 4-3

Symbols (Geometry)	Significance
Floral	Beauty
Rectangle	Symmetry/Wood Element
Round/circular	Heavenly blessing/completeness/ Gold Element
Square	Stability/earthly blessing/ Earth Element
Triangle	Instability/Fire Element
Trigram	Mythical power
Trigram *qian* 乾	Vitality/heaven
Trigram *kun* 坤	Accentuation/earth
Trigram *chen* 辰	Changes/thunder
Trigram *kan* 坎	Spiritual strength/moon
Trigram *ken* 艮	Halting/mountain
Trigram *sun* 巽	Growth/wind
Trigram *li* 离	Separation/lightning
Trigram *dui* 兌	Satisfaction/water
Tortoise shell	Longevity
Zigzag shape	Movement/Water Element

Table 4-4

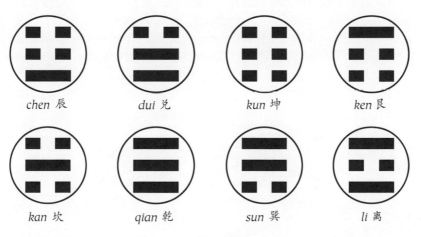

chen 辰 dui 兌 kun 坤 ken 艮

kan 坎 qian 乾 sun 巽 li 离

Figure 4-3 (See Table 4-4)

Auspicious trademarks based on the symbols previously mentioned in Table 4-1 are shown in Figure 4-4.

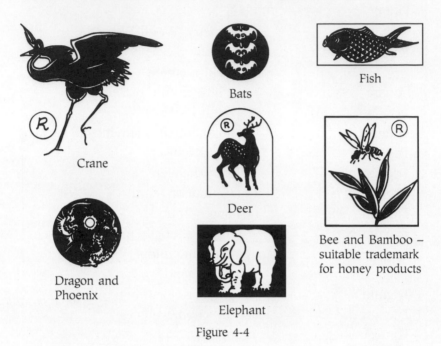

Crane

Bats

Fish

Deer

Dragon and
Phoenix

Elephant

Bee and Bamboo –
suitable trademark
for honey products

Figure 4-4

LINEWORK

Lines in a logo make patterns, symbols and pictures and they must be wisely used and organised in order to transmit a clear message. Every line used must be well placed to create the most effective design. Wavy lines suggest movements and are often used to depict marine-related activities or products as shown in Figure 4-5.

(a) (b)

Figure 4-5

Radiating lines imply the sun's rays or active functions or directional movements. For example, a photographic shop named K Photography may use radiating lines to symbolise the shutters of the cameras and the letter K may be superimposed on the radiating shutters as shown in Figure 4-6.

Figure 4-6

Radiating lines may also imply motion just like the radiating spokes of a wheel. So a company that wishes to make speedy progress may employ a stylised pattern of a wheel to generate the design of its logo.

Lines may be created to give symmetry, contrast, focus, rotation, reflection and movement in a logo as demonstrated in the examples in Figure 4-7.

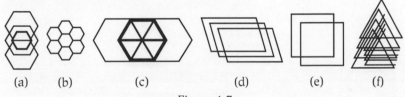

(a) (b) (c) (d) (e) (f)

Figure 4-7

Lines may be created by hand or an instrument such as a compass, brush, pencil, etc. They may be carefully drawn, solid, broken, vertical, horizontal, diagonal or free flowing. They may be drawn to suggest curvature, progression, perspective, regular pattern or rhythm as shown in Figure 4-8.

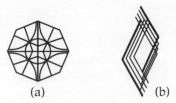

(a) (b)

Figure 4-8

Lines may be used to represent a significant object or meaning. For example, the sketch of lines in Figure 4-9 indicates musical notes and thus portrays the functions of the company which sells music books.

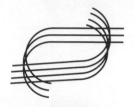

Figure 4-9

However, it is important to ensure that the various types of line are joined in an agreeable pattern. For example, the transition of a straight line to a curved line must be gradual and vice versa. Lines must be formed in a coherent manner to make proportionate shapes or patterns. The diagrams in Figure 4-10 use lines, letters and symbolic forms to achieve a graphic effect in trademarks.

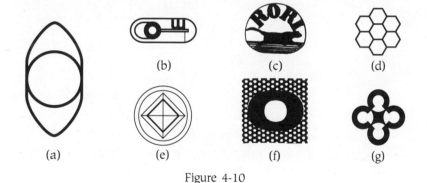

Figure 4-10

SPACE

Numerous shapes can be derived from nature. A leaf, a branch, a shell or a drop of water which may seem trivial may serve as a source of inspiration to the designer of a logo. A simple shape or two simple elements may be assembled to form a novel design. However, a successful design must demonstrate a sense

of unity and harmony in the design. Besides being aesthetic, the design must be relevant as demonstrated in the example in Figure 4-11. This logo is more suitable for a builder of classical buildings than modern structures.

Figure 4-11

A logo is limited in size and space. Therefore, the designer of a logo must arrange all the design elements within the limited space to make them as aesthetically pleasing, expressive and representative of the corporate image as possible. Symbols in a logo must be so arranged that there is space around them. The graphic forms must be distinguished from the space. Congestion and confusion in the design must be avoided.

There are positive (yang) and negative (yin) spaces in a logo. Thus, like a Chinese seal, a logo may be classified under yin (negative) or yang (positive) as shown in the three examples in Figure 4-12.

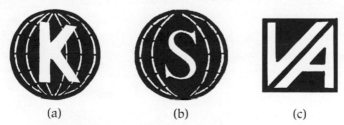

(a) (b) (c)

Figure 4-12

In each logo, the dark areas are yin while the white areas are yang. Logos (a) and (c) have more yang than (b).

The graphic forms and spaces are integrated as a whole composition. The composition should be so designed that no ambiguity is created. The designs in Figure 4-13 are suitable as

logos or trademarks for companies that sell golf balls and other sports equipment.

(a) (b)

Figure 4-13

SHAPE

The basic geometrical shapes are squares, circles, rectangles, ovals and triangles. A square is a strong and balanced shape and to the Orientals, it represents the earth. The circle is a balanced and wholesome shape representing infinity and to the Orientals, it symbolises the heavens. The rectangle is also balanced and it is often used to give a sense of proportion. The oval gives a sense of femininity and spiritualism. The triangle is a determinate shape and can be made to project a variety of forms such as a mountain, tent, an A-framed building, etc. A star-shaped motif suggests brilliance and other intentions such as multi-disciplinary functions as shown in the examples in Figure 4-14. Wavy lines suggest intuitive and flexible approaches (see Figure 4-15). Radiating forms represent multi-directions and networks. Floral motifs symbolise natural and feminine products.

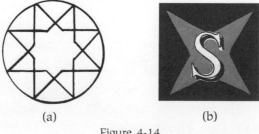

(a) (b)

Figure 4-14

(a)　　　　　(b)　　　　　(c)

Figure 4-15

Although geometric shapes are excellent for logo designs, it is important to ensure that they are not ·applied to suggest monotony or irrationality. For example, a square, circle, triangle or rectangle may be used in duplicates or multiples to suggest movement and dynamism (Figure 4-16).

Figure 4-16

In a logo, it is possible to combine two or even three of the shapes described above, although it is important to give clarity and simplicity to the design. When geometric shapes are used, it is important to ensure that the arrangement of the shapes satisfies aesthetic requirements. Aesthetic satisfaction can be achieved by innovative composition, and colour can produce a special effect called "brightness contrast".

Sometimes simple designs may also be quite effective as shown in the examples in Figure 4-17.

(a)　　　　　(b)

Figure 4-17

51

Figure 4-18 consists of squares of greyish black, with white spaces and junctions in between. The circular red dots are added on the squares. This graphic pattern produces several effects: (1) the orange-tinted dots give life and movement to the overall design and make it more interesting; and (2) the optical illusion created by the red and orange dots makes the grey shadows at the junctions appear less grey.

Figure 4-19 contains five squares of different colours, each with a grey dot in the centre of the square. On the white square, the grey dot appears more conspicuous than on the other coloured squares. This illustrates that colour emphasises form (the dot) and colour (the white square) depending on the other adjacent colours (the other coloured squares).

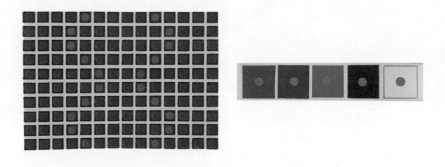

Figure 4-18
Mural and graphic patterns

Figure 4-19
Colour contrast

Geometrical design may be made more dynamic by introducing three-dimensional motifs such as tetrahedrons, cubes, octahedrons, dodecahedrons, icosahedrons and other three-dimensional symbols as shown in Figure 4-20. Well-thought-out relationships of motifs and elements make interesting abstract patterns.

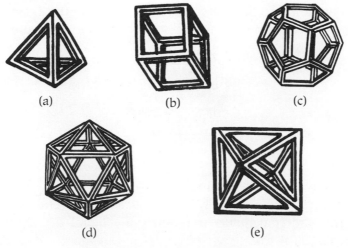

Figure 4-20

Three-dimensional effects may also be created by overlapping geometrical shapes or creating depth through perspective drawings as shown in Figure 4-21.

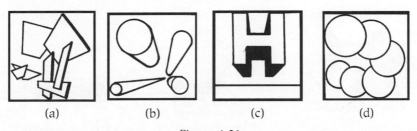

Figure 4-21

ABSTRACT DESIGN

Harmonious and proportionate designs for logos are always well received by users. But an interesting abstract logo stirs emotions and imagination. An abstract design is more than just using graphics to depict a theme. It requires the designer to translate the theme in the simplest way, devoid of complication of ideas.

A real-life object may be translated into a graphic pattern in its simplest form to make an interesting logo. But care must be

53

taken not to make the object look too literal like the example of a logo of a company selling bird nests as shown in Figure 4-22.

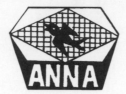

Figure 4-22

However, trademarks may be regarded differently and they often are represented literally in pictorial forms. Several examples of logos and trademarks that are quite literal are shown in Figures 4-23(a)–(k).

(a) Umbrella maker

(b) Bell maker

(c) Key maker

(d) Bicycle maker

(e) Magnifying glass manufacturer

(f) Pipe manufacturer

(g) Trademark for spoon

(h) A company in Paris

Figure 4-23

(i) Clock maker

 (j) Insecticide
manufacturer

 (k) Food products
for birds

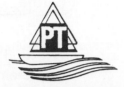

(l) Logo of a company selling small
sailing boats

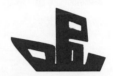

(m) Logo of a shipping company
with the initials OPB

Figure 4-23 (contd)

If an object is used to represent the function of a company, it should be translated into a more abstract form as shown in the examples in Figure 4-23(l) and (m).

Through the use of geometric patterns and lines, evocative and innovative designs evolve. Symbolism and stylisation may be used for simplification of forms and motifs. Colours may be employed effectively to add contrast and interest to the logo. The same black and white, negative and positive patterns may be used to give a variety of patterns for the consideration of a logo design as shown in the examples in Figure 4-24.

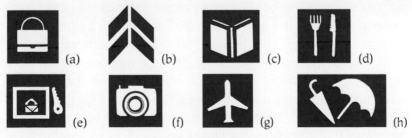

Figure 4-24

Logos for (a) a company selling bags, (b) an airline company, (c) a company selling books, (d) a restaurant, (e) a company selling locks, (f) a company selling cameras, (g) an airline company, (h) a company making umbrellas.

Abstract designs involving lettering should be legible even though it is transformed into abstract figures as shown in Figure 4-25.

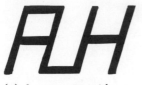 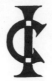 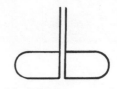

(a) A company with initials AUH

(b) A company with initials IC

(c) A company with initials db

Figure 4-25

COLOUR SCHEME

Strong colours in a logo are attractive to the eye. The primary colours (magenta / red, blue and yellow) are very strong colours and may be used as a powerful stimulus. Intermediate colours such as green and purple are refined and the diluted tonal values are less powerful and more subtle as shown in Figure 4-26.

The colours of nature stir the moods and emotions of Man. For centuries, the spiritual aspiration of Man has been expressed by the use of stained glass in Gothic cathedrals and by the brightly painted columns and roof ornaments of Chinese temples.

In the context of this book, the purposes of colour schemes are to give a sense of identity and character and to create three-dimensional spatial effects on the logos and trademarks. However, colours should not be used just for emphasising form and space in the logos but also for symbolism and for balancing the yin and yang of the logo design. The colour scheme should not be too overpowering (too much yang) or too monochromatic (too much yin). For good feng shui, the colour scheme used should be compatible to the user's birth Element. For example, if the logo is designed for an individual whose birth Element is Fire, the colour that complements Fire is yellow (Earth Element). For corporate companies, the corporate colour scheme should be considered.

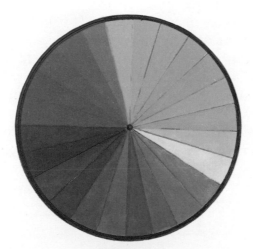

Figure 4-26
Colour chart

Warm colours such as red, orange and yellow are yang while cool colours such as blue and green are yin. Having referred to the user's Element or the company's corporate colour policy, two tints of colour on the opposite sides of the colour wheel may be used to give a balanced scheme.

To the Chinese, colours carry with them certain significance and symbolism. Red symbolises joy and auspiciousness, yellow for royalty and prominence, green for longevity and youthfulness, blue signifies spiritualism and heavenly blessings, black for sadness and somberness, while white is a sign of mourning and purity.

In life, everything we see has colours, so colours are considered more important than forms. However, in logo design, both colour and form must be considered together. Colour and form are closely linked because colour enhances form, while form affects colour. Colour may be used to exaggerate, disguise or mask form. When a grey dot is pasted on a white, black or coloured paper, the grey dot has a stronger effect upon the white than the black or strong-coloured (orange, blue and red) paper. This proves that colour emphasises form as well as affects the colour of the form.

It has also been proven that related values of colours tend to cling together and affect the apparent size and form of design elements. Colour schemes may be monochromatic (based on one hue), apposite (based on closely related hues) or complementary (two hues diametrically opposite on the colour wheel). A complementary colour scheme is most harmonious and it can be achieved by using a cool (yin) and warm (yang) colour. A vivid example is shown in Figure 4-27, illustrating the logo of the Swan Lake Motel.

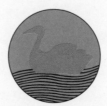

Figure 4-27

A travel agent may use the logo in Figure 4-28 to illustrate flight and travel. But red (Fire Element) is in conflict with black (Water Element). Therefore, this logo should be modified by bringing in the colour green.

Figure 4-28

A publishing company may use the book and its initials in harmonious colours as demonstrated in Figure 4-29.

Figure 4-29

A strong contrast of colours such as black and red (as shown by the logos in Figure 4-30 of a blood donation organisation, a company with an initial B and another with an initial M) may be effective as a colour scheme but in feng shui terms, black represents Water which is in conflict with red representing Fire.

(a) Blood donation (b) Company with (c) Company with
 organisation initial B initial M

Figure 4-30

To make it auspicious, Wood (green) must be brought in as demonstrated in Figure 4-31.

Figure 4-31

A Chinese company may use Chinese motifs to depict its cultural roots (see Figure 4-32).

Figure 4-32

For instance, a Chinese company whose name has four initials may group the initials in an example as shown in Figure 4-33.

Figure 4-33

A cathedral builder may use a complicated logo, as shown in Figure 4-34, to fully illustrate his activities.

Figure 4-34

Yellow (Earth) and black (Water) are not compatible in feng shui terms because Earth absorbs Water in the cycle of Destructive Elements (see Figure 4-35(a)). However, white (Gold) is compatible with Water and so it neutralises the colour scheme and makes it auspicious (see Figure 4-35(b)).

 (a) (b)

Figure 4-35

Red (Fire) and yellow (Earth) constitute a compatible colour scheme as shown in Figure 4-36.

Figure 4-36

Green (Wood) and black (Water) are compatible colours for designing logos (see Figure 4-37). Even though the use of a triangle (Fire) symbol is considered in conflict with Water but the combination of Fire, Wood and Water Elements is auspicious.

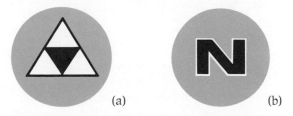

(a) (b)

Figure 4-37

Blue denotes heavenly blessings and yellow is Earth. Thus, the colour scheme in Figure 4-38 is compatible.

Figure 4-38

CHAPTER FIVE

AUSPICIOUS AND INAUSPICIOUS LOGOS AND TRADEMARKS

The design and feng shui of logos have already been discussed. Therefore, it is clear that auspicious logos and trademarks should be aesthetically designed with meaningful images composed in balance and harmony, proportionate and artistic in terms of spatial composition, and compatible in colour scheme. They also have to be symbolically auspicious in feng shui terms. On the other hand, inauspicious feng shui logos and trademarks are those that are designed with poor taste, inauspicious symbols, imbalance of yin / yang elements, conflicting Five Elements, incompatible colour scheme, and inauspicious measurement.

Appropriate themes and the fundamental design philosophy based on aesthetic visual and graphic perception have been mentioned in Chapter One and the feng shui of logos and trademarks in Chapter Two. In this chapter, the author has created numerous examples of logos and trademarks that are suitable or unsuitable for various types of usage or organisation. It is hoped that these examples will help to demonstrate the approach to the design of logos and trademarks.

EXAMPLES OF AUSPICIOUS FENG SHUI LOGOS AND TRADEMARKS

The prerequisites for good feng shui designs have already been discussed in Chapter 4. In this section, a series of logos and trademarks have been created to demonstrate how geometrical forms, symbols and images can be used as design tools. Some of these examples illustrate the concept of combining appropriate design and auspicious feng shui.

Thirteen designs suitable for logos and trademarks using various letter types and shapes to form a theme of balanced yin and yang qualities (yin qualities refer to black and yang qualities refer to white colour) are shown in Figure 5-1. The designs combining a square with a triangle (h), a square with a circle (g), and a circle with the letter M (j) are more successful in feng shui terms because of the compatibility of the Five Elements.

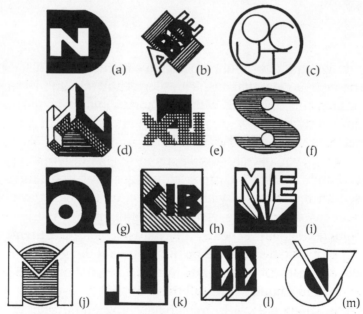

Figure 5-1

(a) N superimposed on D, (b) ABCDE overlapping, (c) OCTU inscribed in a circle, (d) HU in three-dimensions, (e) XU superimposed on a square, (f) S holding two circles, (g) A in a square, (h) CIB in a square of yin and yang, (i) ME in three-dimensions, (j) M in a circle, (k) NU in a square, (l) CC in three-dimensions, (m) V overlapping O.

The sixteen logos, balanced in yin and yang elements, as shown in Figure 5-2, are suitable for financial and large corporations. Those designed within a square are better suited for financial and banking centres whereas those designed within a circle are more suitable for governmental and small-sized companies because of the nature of the elements.

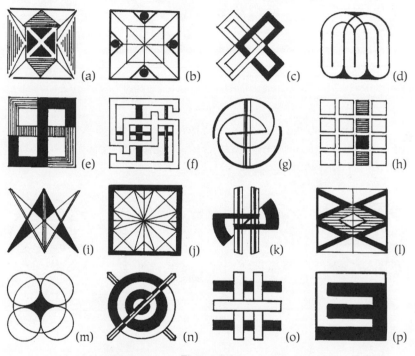

Figure 5-2

Figure 5-3 shows three balanced logos suitable for publishing houses and book companies.

(a) (b) (c)

Figure 5-3

The four logos shown in Figure 5-4 are appropriate for electronic and electrical firms. Note that images of cables and flashes of lightning are used to convey the appropriate messages.

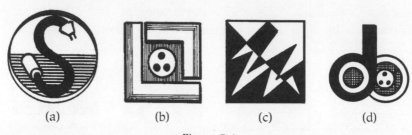

(a) (b) (c) (d)

Figure 5-4

The four logos or trademarks shown in Figure 5-5 are suitable for companies dealing in film and photographic equipment. Note that films and cameras are used as themes.

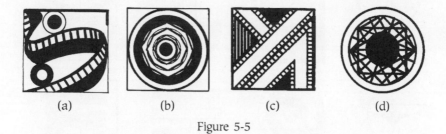

(a) (b) (c) (d)

Figure 5-5

The four logos shown in Figure 5-6 are designed for builders and contractors. Note that building materials and building forms are used as themes.

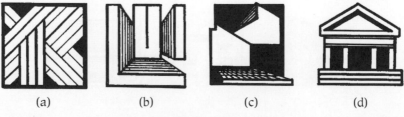

(a) (b) (c) (d)

Figure 5-6

The twelve logos and trademarks using letters and other symbols as design elements in Figure 5-7 are suitable for sports clubs and activity-orientated organisations. These examples are balanced in yin and yang elements.

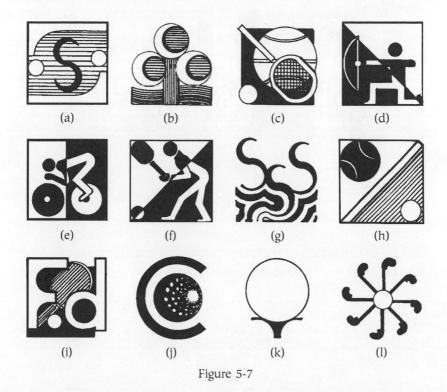

(a) (b) (c) (d)

(e) (f) (g) (h)

(i) (j) (k) (l)

Figure 5-7

The three balanced logos, shown in Figure 5-8, employing letters as design elements are suitable for financial institutions.

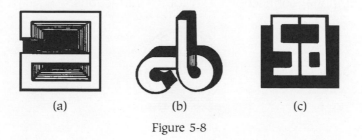

(a) (b) (c)

Figure 5-8

The following six logos based on an abstract theme may also be considered auspicious because of the balance in design (see Figure 5-9).

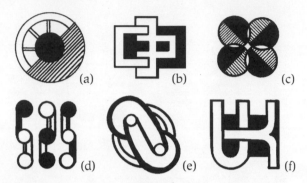

Figure 5-9

The following ten logos have been created with auspicious symbolic and abstract themes. The first example, shown in Figure 5-10, is suitable for a country club. Note that a tree with many leaves is used to indicate the fresh air and green country-side enjoyed by the club members.

Figure 5-10

Figure 5-11 shows a logo suitable for an international travel agency. Note that the stylised globe and pyramid signifies international connections and tourist attractions.

Figure 5-11

Figure 5-12 shows three designs suitable for dynamic companies dealing in various trades.

Figure 5-12

A design suitable for a chess-making company is shown in Figure 5-13.

Figure 5-13

A proposal for a company that offers many services is demonstrated in Figure 5-14.

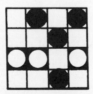

Figure 5-14

The design shown in Figure 5-15 is appropriate for a paper-making factory.

Figure 5-15

The design proposal shown in Figure 5-16 is generally suitable for a driving school. Note the use of a human figure and wheel in the design.

Figure 5-16

The design shown in Figure 5-17 is generally appropriate for a construction company. Note that the man wearing a helmet represents the construction worker.

Figure 5-17

EXAMPLES OF INAUSPICIOUS FENG SHUI LOGOS AND TRADEMARKS

Figures 5-18 to 5-29 show twelve logos created by the author to demonstrate inauspicious feng shui designs. The first logo, shown in Figure 5-18, shows a puzzle with an unclear theme which spells problems and confusion.

Figure 5-18

Figure 5-19 shows a cross and part of a circle resembling a tombstone which indicates death and so it is inauspicious.

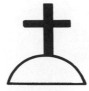

Figure 5-19

Figure 5-20 shows a symbol representing fire with water dropping over it. Thus, it signifies the short life span of a company.

Figure 5-20

Another inauspicious design (Figure 5-21) shows three arrows shooting downwards portraying a downward trend in business.

Figure 5-21

The design in Figure 5-22 shows a two-headed arrow, signifying conflict within a company.

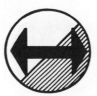

Figure 5-22

This design with very thin letters I and H inside a circle is an imbalanced design (see Figure 5-23).

Figure 5-23

This design is obviously inauspicious as the question mark spells uncertainty (see Figure 5-24).

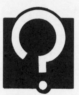

Figure 5-24

This logo indicates conflict and infighting within the company (see Figure 5-25).

Figure 5-25

This is the symbol of a broken heart symbolising a company without unity (see Figure 5-26).

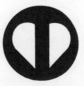

Figure 5-26

This design may look rhythmic but on closer examination, it appears to be the face of a sad figure (see Figure 5-27).

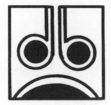

Figure 5-27

This design proposal is balanced in yin and yang elements but the arrows show a conflict of interests (see Figure 5-28).

Figure 5-28

Figure 5-29 shows a design proposal with a cross and is therefore inauspicious.

Figure 5-29

The diagrams in Figure 5-30 have been created to show trademarks based on numerous themes and subjects ranging from birds (e.g. rooster, owl, swallow); insects (e.g. butterfly, bee);

animals (e.g. horse, rabbit, bear); fruits (e.g. apple); objects (e.g. arrow, bell, envelope, hammer) to plants (e.g. flower). They are not necessarily inauspicious, but if a trademark spells plight, downturn, loneliness or unhappiness, it is not auspicious.

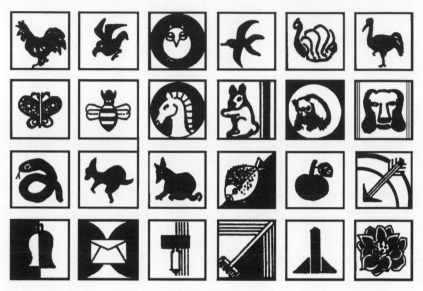

Figure 5-30

CHAPTER SIX

EXAMPLES OF LOGOS OF WELL-KNOWN CORPORATIONS

During the course of researching the subject of logos, trademarks and signboards, I came across many companies whose logos or trademarks had been changed because their former logos were inauspicious or poorly designed. Some cases have interesting historical backgrounds and stories connected with their logos. I am grateful to these companies that have granted me permission to reveal the design philosophy of their logos and the historical background of their trademarks.

I sent out a number of letters requesting local and over-seas local as well as international companies to grant me permission to publish their logos and trademarks. I am most grateful to those companies who not only granted me permission to include their logos in this book but also supplied me with information of the design intentions of their logos.

The logo of Aalborg Ciserv (Singapore) Pte Ltd is shown in Figure 6-1. The company describes the philosophy of the logo

Figure 6-1

as follows:

The future is blue
Like the sky and the sea.
An image of a process
steam evaporating
in a shimmering haze.
Energy and power
as infinite possibilities.
A cleaner environment.
Stronger prospects for the future

The logo of Decor Arts Gallerie (as shown in Figure 6-2) is auspicious because the colour scheme of black (Water) and green (Wood) is harmonious in feng shui terms – water nourishes wood. The logo consists of the Chinese characters *de* 得 (yang) *gao* 高 (yin) which mean progress.

Figure 6-2

The logo of Nikko Merchant Bank (Singapore) Limited is shown in Figure 6-3. The logo is simple yet attractive because of the colour of the lettering which reflects the strength and positive attitude in the bank's offer of its services to its clients.

Figure 6-3

The logo of Westpac Banking Corporation (see Figure 6-4) consists mainly of words made up of yin and yang letters with emphasis on the letter W, which is stylised and bold. It is an effective logo.

Westpac

Figure 6-4

The logo of the Australia and New Zealand Banking Group Limited, ANZ Group, is effective and bold (see Figure 6-5). It consists of bold letters, ANZ, printed in a mixture of solid (yang) and broken (yin) lines which achieves the balance of yin and yang elements. In the Graphic Standards Manual of the bank, the ANZ monogram is described as follows:

In a sophisticated design combining the initials for Australia and New Zealand with a series of network lines, the ANZ monogram symbolises over 150 years of business combined with the high technology of contemporary banking. The network lines reflect lines of connection: the human connections between bankers and their customers, the electronic connections between transactions, and the business connections between ANZ branches and offices throughout the world.

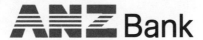 Bank

Figure 6-5

After the formation of Air-India International in 1948, four Lockheed Constellations were bought for international flight operations. The airline's management had a logo specially designed to denote speed and universal appeal. The design chosen showed the archer, Sagittarius, the ninth sign of the Zodiac. This symbol which shows Sagittarius in the act of shooting an arrow

denotes speed and movement and is thus an appropriate logo (see Figure 6-6).

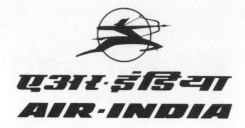

Figure 6-6

The logo of Lufthansa is most creative as it depicts the essence of design: "less is more" (see Figure 6-7). The logo shows a soaring crane enclosed by a circle. The emblem is graphically simple yet significant and is perceived as synonymous with quality, forming the basis for a sophisticated information system. It also suggests quality, giving emphasis to efficiency.

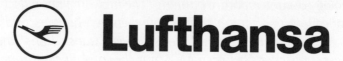

Figure 6-7

The logo of The Chase Manhattan Bank, N.A., shown in Figure 6-8, is strong and symbolic of unity, strength and continuity. This is a good symbol for a bank as it reflects its solid organisational structure and strong financial backing.

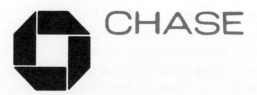

Figure 6-8

The logo of a noted architectural firm, Arkitek MAA, is most artistic and balanced (see Figure 6-9). It consists of geometrical shapes of squares and triangles. Squares represent Earth while triangles Fire, and Earth is compatible with Fire. The firm's initials MAA are seen in the abstract.

Figure 6-9

The logo of the Singapore National Printers Limited is attractive and meaningful (see Figure 6-10). Smooth-flowing gold element signifies its smooth-flowing printing business and the circular elements symbolise the web press running at high speed. The logo is significant and auspicious.

Figure 6-10

The logo of the DeLima Resort Kuala Muda is interesting and pictorial. It is made up of yin (cool) and yang (warm) colours and it depicts the resort being near to the sea. The boat, sea waves, sea gulls, etc., are contained in its initial "d" as shown in Figure 6-11.

Figure 6-11

The logo of Polychem (M) Sdn Bhd is attractive and effective (see Figure 6-12). It is a combination of the letters N and P which are transformed into an abstract form. The red colour symbolises prosperity. Sharp corners and edges in the lettering have been eliminated to represent success in the company's marketing skills in the Southeast Asian region. The letters NP in the logo reflect the company's counterparts in Singapore (NP King Pte Ltd) and Hong Kong (NP King (HK) Ltd).

Figure 6-12

A logo with an interesting background is that belonging to CYC Shanghai Shirt Co. Pte Ltd (Figure 6-13). According to the present managing director, Mrs Fong, CYC Shanghai Shirt Co. Pte Ltd was started by her grandfather, Y C Chiang. Mr Chiang was a master cutter and as the scissors was the tool of his trade, he thought that the scissors was a good symbol for his company's logo. Although he started his business in China, he migrated to Singapore in 1940. Mrs Fong has recently changed the logo of

Figure 6-13

the company as she felt that the scissors cutting across her grandfather's initials CYC was not desirable. Thus, a new logo was designed as shown in Figure 6-14.

CYC

Established in 1935

Figure 6-14

The Bankers Club's logo consists of the initials BC which overlap in an artistic formation of yin and yang letters (see Figure 6-15). It is very well composed.

BANKERS CLUB

Figure 6-15

81

A housing developer, Sunrise Sdn Bhd, has a logo with seven sun rays which, according to the company, spells the following aims (see Figure 6-16):

1. To build quality homes within the reach of most Malaysians.

2. To build homes with an ambience that enhances the quality of life.

3. To be innovative and to apply modern technology.

4. To take due care of the environment.

5. To conduct business with integrity and honour at all times, and not to compromise these principles in the name of profit.

6. To sustain the trust and confidence of Malaysians at all times.

7. To help forge a stronger bond among families which are the foundation of society.

Figure 6-16

An international and well-known accounting firm, Ernst & Young, has an artistic and abstract logo which is balanced in yin and yang elements as the initials of the firm have been transformed into an abstract symbol ⊒⫟ in strokes of three (yang) and two (yin). Harmony is thus achieved (see Figure 6-17).

⊒⫟ ERNST & YOUNG

Figure 6-17

The logo of Wella, a company selling hair care products, is an artistic and expressive design consisting of an abstract image of a lady with long flowing hair and the letters W (yin, Earth Element), E (yin, Earth Element), L (yang, Fire Element), L (yang, Fire Element) and A (yin, Earth Element) (see Figure 6-18). The logo is auspicious because its yin / yang and Elements are balanced.

Figure 6-18

The logo of Mok & Associates is well proportioned and it is a square (Earth Element) artistically divided into shapes (see Figure 6-19). Its colour is gold which is also Earth.

 MOK & ASSOCIATES

Figure 6-19

The logo of the Real Estate Developers' Association of Singapore not only reflects the challenges and roles faced by the Association but also depicts the professional image of the Association (see Figure 6-20). The colours of the logo (green, blue and red) are truly balanced in yin and yang elements.

REDAS

Figure 6-20

Esso's logo (see Figure 6-21) is boldly designed in yin and yang colours with letters having rounded corners.

Figure 6-21

The logo of the Beth Tikvah Synagogue is a star-shaped design inscribed with the Hebrew words for Beth Tikvah in the Star of David as shown in Figure 6-22.

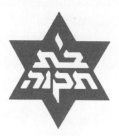

Figure 6-22

An interesting and attractive architect's logo is shown in Figure 6-23. It is the logo of Geoff Malone International, designed by Geoff Malone. It consists of geometric shapes with colours: a black square (black – Water, square – Earth), a red circle (red – Fire, circle – Gold), a purple triangle (Fire Element and colour of Fire which is neutralised by blue) and a green rectangle (rectangle – Wood, green – Wood). These geometric shapes are linked by a fine yellow line (line – Wood, yellow – Earth). It is interesting to note that this logo consists of compatible and incompatible Elements. However, the purple triangle links favourably with the black square and the yellow line that links the red circle to the

green rectangle is broken by the word "international" as Gold and Wood are not compatible. Colours of Fire are compatible with those of Earth but a colour of Fire (red) is not compatible with a colour of Water (black).

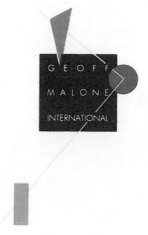

Figure 6-23

Another interesting architect's logo is shown in Figure 6-24. It is made up of a square, a red circle and two triangles. This is a clever combination of geometrical shapes because the triangles (Fire) combine favourably with the square (Earth) and circle (Gold) making the combination Gold, Earth and Fire which is auspicious. After interviewing the architect, it was learnt that the logo is indeed meaningful because the square, the line across, and the twin triangles together represent the initials (AHZ) of the architect's name and the red circle represents the rising sun, symbolising progress and hope.

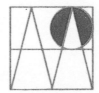

Figure 6-24

Risis Pte Ltd, a company that has the technology to produce gold-plated orchids using real orchids, has an artistic logo printed in gold with strong stylised yang letters (see Figure 6-25). The original Risis logo had the letters joined together and it was difficult to read.

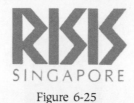

Figure 6-25

BIBLIOGRAPHY

IN ENGLISH

Arnheim, Rudolph, *Art and Visual Perception*, University of California Press, Berkeley, 1974.

Badawy, Alexander, *A History of Egyptian Architecture*, University of California Press, Berkeley, 1966.

Berlyne, D. E., *Aesthetics and Psychobiology*, Appleton-Century-Crofts, New York, 1971.

Birren, F., *Colour and Human Response*, Van Nostrand Reinhold, New York, 1978.

Hartt, Frederick, *Art: A History of Painting, Sculpture, Architecture*, Abrams, New York, 1976.

Lip, Evelyn, "Geomancy and Building", *Development and Construction*, Singapore, No. 1, 1977, pp. 13–18.

Lip, Evelyn, "Feng Shui, Chinese Colours and Symbolism", *Singapore Institute of Architects Journal*, July 1978, pp. 17–23.

Lip, Evelyn, *Chinese Geomancy*, Times Books International, Singapore, 1979.

Lip, Evelyn, *Chinese Temples and Deities*, Times Books International, Singapore, 1981.

Lip, Evelyn, *Fun with Chinese Horoscopes*, Graham Brash, Singapore, 1981.

Lip, Evelyn, *Chinese Temple Architecture in Singapore*, Singapore University Press, Singapore, 1983.

Lip, Evelyn, *Chinese Beliefs and Superstitions*, Graham Brash, Singapore, 1985.

Lip, Evelyn, *Chinese Customs and Festivals*, Macmillan Education, London, 1985.

Lip, Evelyn, *Feng Shui for the Home*, Times Books International, Singapore, 1986.

Lip, Evelyn, *Feng Shui for Business*, Times Edition, Singapore, 1987.

Lip, Evelyn, *Choosing Auspicious Chinese Names*, Times Books International, Singapore, 1988.

Lip, Evelyn, *Notes On Things Chinese*, Graham Brash, Singapore, 1988.

Lip, Evelyn, *Out of China, Culture and Traditions*, Addison-Wesley, Singapore, 1993.

Meyer, Ursula, *Conceptual Art*, Dutton, New York, 1972.

Mulherin, Jenny, *Presentation Techniques for the Graphic Artist*, Phaidon Press, Oxford, 1987.

Needham, Joseph, *Science and Civilization in China*, Cambridge University Press, London, 1982.

Porter, Tom, and Goodman, Sue, *Designer Primer for Architects, Graphic Designers & Artists*, Butterworth Architecture, London, 1989.

Rewald, John, *The History of Impressionism*, Museum of Modern Art, New York, 1961.

Rowntree, Diana, *Interior Design*, RODEC, Middlesex, UK, 1964.

Van Over, Raymond, *I-Ching*, New American Library, Chicago, 1971.

IN CHINESE

Ceng Zinan 曾子南, *Sanyuan Dili Tuwen Jianjie* 三元地理图文浅解, Taipei, Taiwan, 1965.

Gujin Tushu Jicheng 古今图书集成, China, 1927.

Jiang Pingkai 蒋平楷, *Dili Zhengshu* 地理正跣, Taiwan, 1980.

Luojing Xiangjie 罗经详解, Taiwan, no date.

Nan Haiguan 南海关, *Kanyu Xueyuan Li* 堪與学原理, Hong Kong, 1971.

Qing Jiaqing 清家请, *Jiazhai Fengshui* 家宅风水, no date.

Xiao Ji 萧吉, *Wuxing Dayi* 五行大义, China, 1726.

INDEX